HOW TO DRAW ADORABLE

JOYFUL LESSONS FOR MAKING CUTE ART

CARLIANNE TIPSEY

GFB

GIRL FRIDAY BOOKS

 GIRL FRIDAY BOOKS

Published by Girl Friday Books™, Seattle
www.girlfridaybooks.com

Produced by Girl Friday Productions

Design: Debbie Berne
Project management: Leslie Jonath, Connected Dots Media

ISBN (paperback): 978-1-954854-47-5
ISBN (e-book): 978-1-954854-48-2

Library of Congress Control Number: 2022905937

To Ollie and Chloe,
please don't eat this book.

contents

Hi!
I'M Carli

INTRODUCTION

I'VE BEEN ASKED BEFORE WHY I LOVE CUTE ART. The reasons are simple: cute art makes me smile, it makes others smile, and it can bring joy to any moment. There's so much darkness in the world, but as artists, we have the opportunity to shine some light. ✦ But many artists have come to me struggling to create cute art. I found that they were given overly simplified advice, like "use round shapes" and "give it big eyes," but not a lot of advice on the basics of cute design. Cute art looks simple, but you still need to be thoughtful about storytelling, design, and proportion to really nail it.

In this book, I don't want to teach you only one way to create cute art. I want you to understand what makes something cute, so that you can apply that understanding to your own style. But you won't just learn all of my cute secrets, you'll also find step-by-step tutorials, reference sheets, and plenty of space to practice. By the time you reach the end of this book, you'll be making so much cute art that you'll run out of fridge space to show it off!

I want you to be successful, so if at any point you are struggling to learn a lesson, I want you to try three things. First, make sure you understand all the words I'm saying. I have tried to keep the language simple, but just one misunderstood word can make everything feel mixed-up. After you've done that, if you're still struggling, try to apply the lesson in the simplest way possible, or go back a step. For example, if drawing human faces is too hard, try some cartoony ones for a while. If you can't nail complex emotions, practice the five basic ones some more. Finally, learning art just takes time. Keep practicing until you get it, and then move forward a little at a time. I try to admire my frustrations as a sign that I'm learning and growing.

NOW BEFORE YOU DIVE INTO ALL THE CUTE IN THIS BOOK, I want to offer you the most important tip of all . . . ready? Trust yourself and have *fun*. It is easy to fall into the trap of trying to create art that you think is

"right" or that other people will like. And although reading books (like this one!) is great, the best lesson you can learn is to trust your own instincts.

Take everything you can from the suggestions in this book and try it out for yourself. Then decide if you agree or disagree with the advice—do *you* think it looks better? Use these lessons to make art that you think looks good (or cute). Never forget that your opinion is important—and when it comes to *your* art, *you* decide.

I hope you have loads of fun and create tons of cute drawings! I can't wait to see what you make.

Ready to get your cute on? Let's go!

Carlianne

@carliannecreates

– THE MEANING OF –
CUTENESS

SO WHAT DOES "CUTE" ACTUALLY MEAN? If you ask the dictionary, "cute" is just an adjective that means "attractive"—in an endearing sort of way. But we can also define "cute" as something that brings us joy, something that's fun and appealing to the eyes, something that inspires those fuzzy, feel-good feelings of love and affection. So our first goal when making cute art will be to achieve *allll* of that. ✦ Of course, what each of us finds pleasant (or fuzzy feeling–inducing) is highly subjective— and can even change as society adjusts to new trends or standards of beauty. By understanding what many people find cute, you can control the effect your art has on others—and maybe, just maybe, you can change people's ideas about what is cute and what isn't. But first, we have to learn a whole lot about cuteness.

So what is "cute," anyway?

The drawing below is adorable! But why? Let's take a look at that definition again.

WHY IS IT CUTE?

Things that are adorable:

- Make us feel happy
- Are pleasant to look at
- Inspire feelings of love

let's break them down! →

CUTE STUFF . . . MAKES US FEEL HAPPY

Think of some of the everyday sights that make people feel happy.

BABIES

Ever see a puppy or kitten and just burst into a smile?

HAPPY FACES

Smiles are contagious. It's science!

COLORFUL

Happy colors tend to be light, bright, and make us feel good.

CUTE STUFF . . . IS PLEASANT TO LOOK AT

Here are some examples of imagery that are oh so easy on the eyes:

ROUND SHAPES

Round shapes have no sharp corners, so they feel friendly and huggable.

friendly sturdy edgy

COLORFUL

Pastels are pleasant to look at because they are soft and sweet.

BABIES AGAIN

Babies are easy on the eyes because, well, they have cute little bodies that we just love to love.

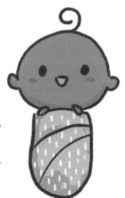

CUTE STUFF . . . INSPIRES FEELINGS OF LOVE

Think of some of the ways that images make us feel all warm and fuzzy inside.

LOVE

Seeing love makes us *feel* love.

KINDNESS

When we see characters being kind to each other, it makes us feel love toward them.

BABIES! AGAIN?!

Now we know why babies are so cute! They inspire all the feels.

PRACTICE TIME ↘

WRITE DOWN SOME VISUAL CUES THAT . . .

MAKE YOU FEEL HAPPY

ARE PLEASANT TO LOOK AT

INSPIRE FEELINGS OF LOVE

MAKE YOU FEEL UNHAPPY

ARE UNPLEASANT TO LOOK AT

INSPIRE FEELINGS OF DISGUST

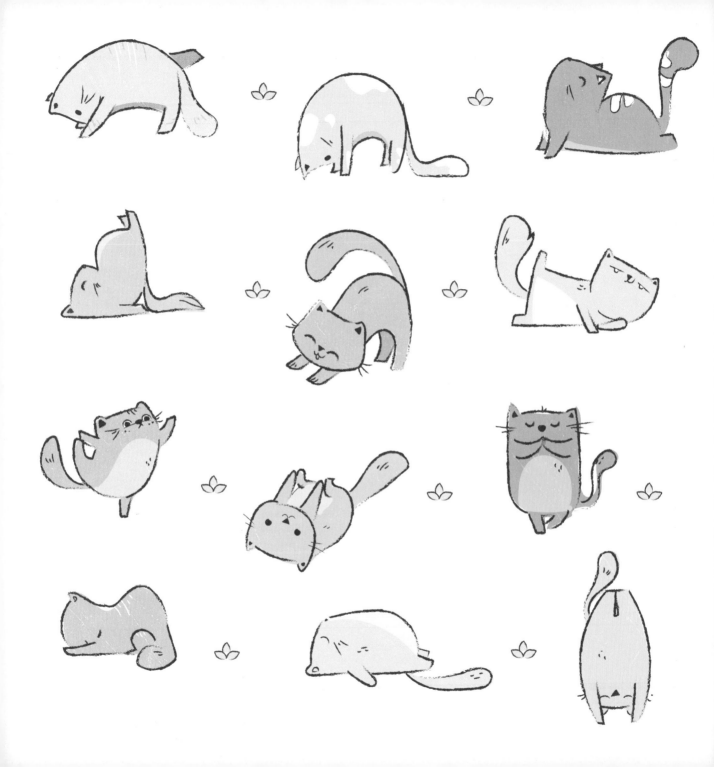

- NOW LET'S -
WARM UP

LEARNING TO CONTROL YOUR PENCIL is the key to making the images in your head appear on paper. I can still remember the first time I "told" my hand to draw a circle—and my hand actually *did* the thing. You may have heard you need to do ten thousand drawings before sketching becomes more natural—which is a lot. But if you focus on drawing simple shapes and on controlling how hard or lightly you press pencil to paper, I believe you can sidestep this requirement and start drawing the things you want to draw faster! ✦ This chapter includes basic drawing exercises and design tips so you can fast-track your art journey. Easy-peasy.

drawing with a light touch

The first step to gaining pencil control is learning how to draw *lightly*. Once you've mastered the light touch, you can practice shifting from light pressure to heavy pressure on demand, giving you more confidence and control.

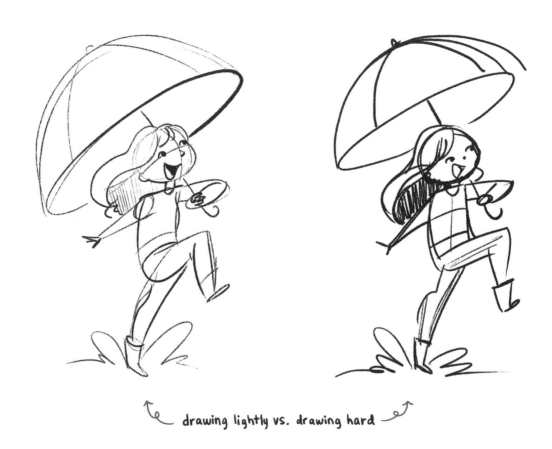

drawing lightly vs. drawing hard

WHY DRAW LIGHTLY?

When you draw with a gentle touch, there's less friction between your pencil and paper—so your lines end up looking smoother and cleaner.

Plus, drawing lightly lets you make a loose sketch first. Then, once you've figured out the shapes, you can trace over your sketch with darker lines. The lightly drawn lines will just fade into the background, adding texture to your drawing!

i've TRIED drawing lightly but i can't!

Practice makes for picture-perfect art! Try these techniques to help find your groove.

DRAW WITH YOUR SHOULDER

Try to keep your wrist and elbow still while using your shoulder to move the pencil. This helps you stay loosey-goosey.

TWEAK YOUR PENCIL GRIP

If you're having trouble drawing lightly, try holding the middle of your pencil instead of the tip.

did you know?
Sitting upright and drawing on an elevated surface keeps your neck and back comfortable too!

PRACTICE TIME

TRACE THESE PATTERNS LIGHTLY

DRAW SOME PATTERNS OF YOUR OWN

ALTERNATE LIGHT AND HEAVY LINES

LIGHT TO HEAVY LINES

LIGHT TO HEAVY AND BACK TO LIGHT LINES

DRAW SOME LINES OF YOUR OWN

conquering straight lines

Now that you're all warmed up, let's tackle the simplest of shapes—okay, well, it's not quite a shape yet, it's a line. Drawing a straight line is nothing to sneeze at—it's surprisingly hard! But doing simple exercises like these is great practice and will make drawing more complicated shapes easier in the future.

STEP 1 *TAKE A GHOST SWING*

Have you ever seen a golfer take a swing at a ball? Did you notice they take a few practice swings first? I like to call this motion "ghosting." Ghosting the beginning of the line before putting your pencil to paper helps you draw with more confidence—and make more boo-tiful art.

STEP 2 *TRY DIFFERENT SPEEDS*

Practice drawing at various speeds to see which one works best for you. I have found that drawing too slowly can make my lines wobbly, but drawing too fast can make my lines less precise. Every artist has their own sweet spot.

PRACTICE TIME ↘

TRACE THESE STRAIGHT LINES

PRACTICE DRAWING YOUR OWN STRAIGHT LINES

the perfect circle

Honestly, it's okay if you can't draw a perfect circle—we can leave that to compasses (or computers)! Our goal is just to get close to drawing a circle-y shape and to feel comfortable with the process. The good news? You've been drawing circles ever since you learned to write.

DRAWING SMALL CIRCLES: EASY AS A-B-C

The alphabet is full of small circles (and several other shapes and lines to boot). Drawing *feels* different but it uses the same skills. So try to draw like you write!

abcde 0,1,2,3

look at all those circles!

USE YOUR SHOULDER

Large circles can't be drawn with your wrist—they're too big!
Use your shoulder to create big, open movements instead.

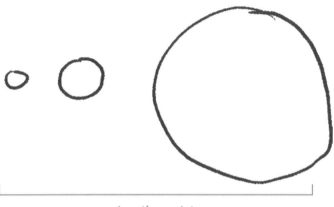

using the wrist

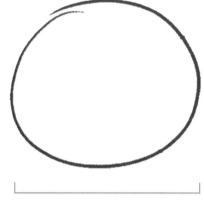

using the shoulder

USE A SQUARE TO CHEAT THE SYSTEM

Squares are easier to draw, right? Use the simple geometry
trick below to make perfect circles every time. Easy!

Your circle
Should barely
touch the
edges of the
cross.

1. Draw a square.

2. Draw a line from
corner to corner to
create an X.

3. Use the center
of the X to draw a
cross.

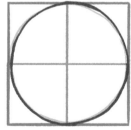

4. Use the cross to
draw a circle!

PRACTICE TIME ↘

TRACE THESE CIRCLES

MAKE AN X TO FIND THE CROSS, THEN DRAW A CIRCLE

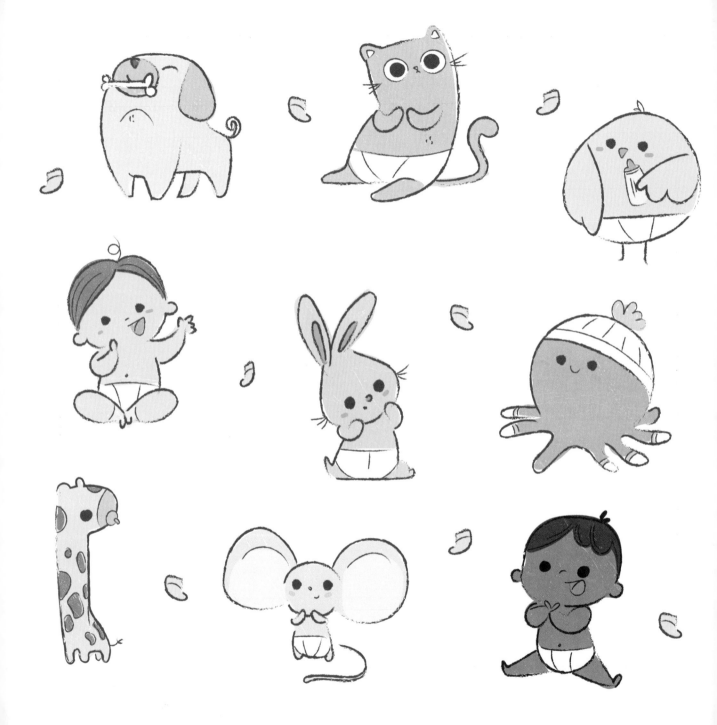

- THE FUNDAMENTALS OF -
BABY CUTE

IT'S A SCIENTIFIC FACT THAT NATURE MADE BABIES CUTE to increase their chances of survival. Now you might like kittens more than puppies, or puppies more than human babies, but the fact remains that *babies of all species* are stinkin' cute. So when we see something that reminds us of babies, we think cute thoughts. ✦ In this chapter, I break down how to create a baby-cute look and go over some common mistakes that might make your characters look the wrong age.

≳important note≲

In this book, I often mention that A is cuter than B. But that doesn't mean that A is *better* than B. When you create your own cute style, you get to decide if you want to make something super baby-cute (more traditionally cute) or cute in a different, more unique way (less traditionally cute).

proportions of the face

One of the most important things to keep in mind when creating cute characters is the proportions of the face. By making slight tweaks to the placement of the eyes and nose, we can make a character look younger and cuter.

In children, facial features tend to be closer to the lower half of the face. The eyes, nose, and mouth are close together, with a large forehead and a small jaw.

:did you know?:

"Proportions" is just a fancy way of saying how different parts of the body compare to each other in size.

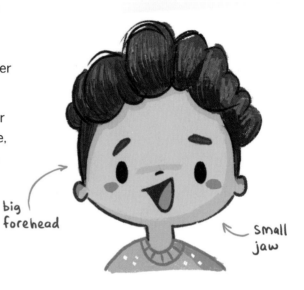

big forehead

small jaw

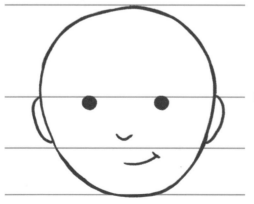

average adult proportions

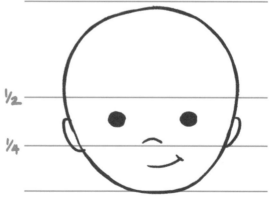

½

¼

average baby proportions

Let's put these proportions to work and see if they help up the cuteness factor!

STEP 1 *LOWER THE FACE*

By using baby-face proportions on our character, we can make them look more baby cute.

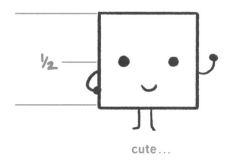

cute...

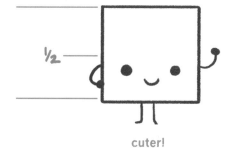

cuter!

STEP 2 *MOVE THE EYES FARTHER APART*

If you keep the eyes close together, you'll get a cutie adult. To make your characters look younger move their eyes farther apart.

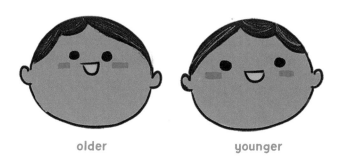

older younger

use steps 1 and 2 to get this little cutie!

youngest

OPTIONAL STEP **WIDEN THE FACE**

As children grow, their jaws get longer, which makes their faces look less wide. This means a narrow face can feel more grown up than a wide one.

⸻tip⸻

A wide face is optional for cuteness, but it's common in little ones. So if you're drawing a child and they're not looking young enough, you'll want to check that head width.

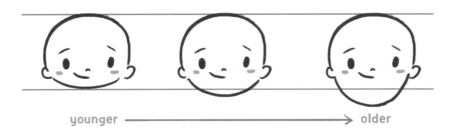

younger ⟶ older

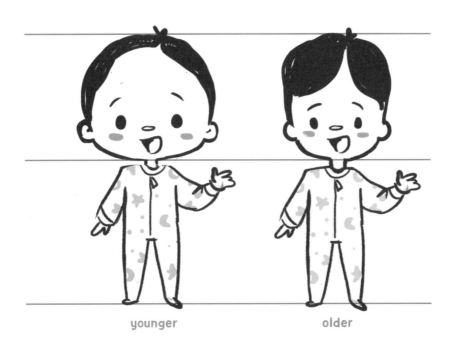

younger older

Is your character not feeling cute enough? Check the proportions against the baby-cute design ideas to see what can be changed up.

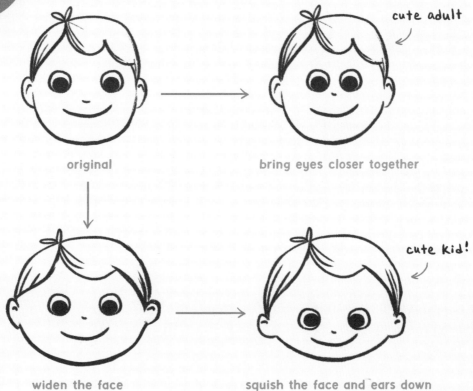

original

bring eyes closer together

cute adult

widen the face

squish the face and ears down

cute kid!

tip

For an extra boost of cuteness, try big eyes and a little mouth!

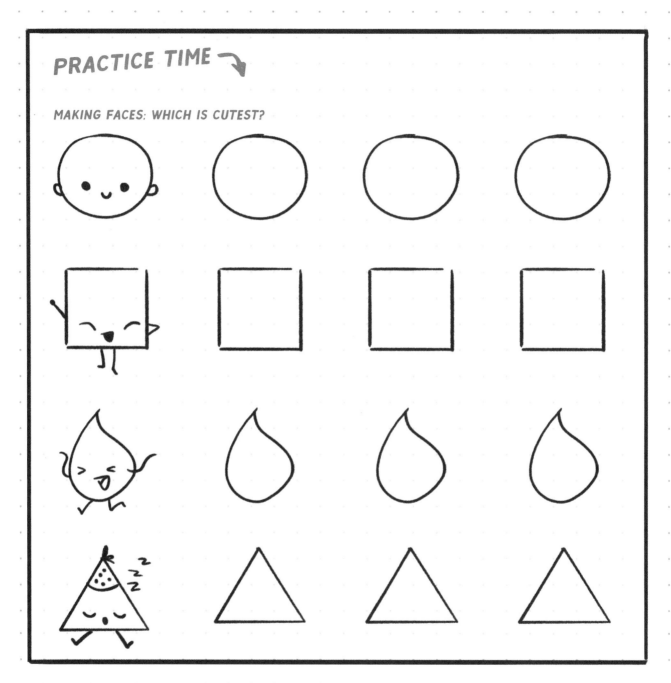

PRACTICE TIME

MAKING FACES: WHICH IS CUTEST?

parts of the face

We know that big heads are cute (and we cannot lie). But what about all the other parts of the face? Let's look into the fun features you can choose for your character.

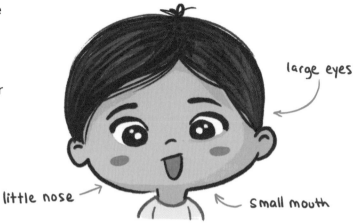

large eyes

little nose →

← small mouth

EYES

The eyes are the windows to the soul—and the larger they are, the kinder and friendlier our characters will look!

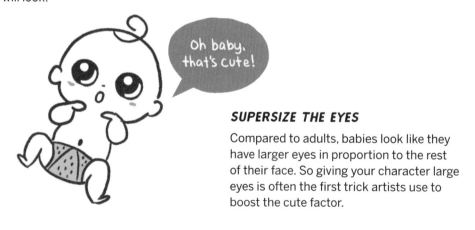

Oh baby, that's cute!

SUPERSIZE THE EYES

Compared to adults, babies look like they have larger eyes in proportion to the rest of their face. So giving your character large eyes is often the first trick artists use to boost the cute factor.

BUT WAIT, THERE'S MORE

The character on the left has bigger eyes, but it's not as cute. Why? Because it's not just the size of the eyes that makes something cute—it's the size of the pupils!

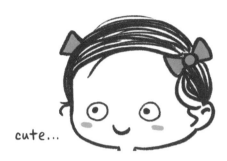

cute...

large eyes with
small pupils

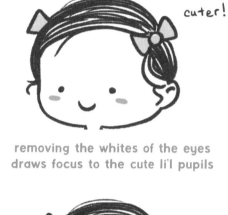

cuter!

removing the whites of the eyes
draws focus to the cute li'l pupils

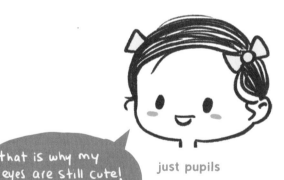

that is why my
eyes are still cute!
they are ALL pupil.

just pupils

large eyes and pupils

⸱did you know?⸱

Our pupils widen when we're happy! So big eyes and pupils remind us of babies and happiness. Double cute points!

NOSE

To tell you the truth, you don't have to give your character a nose at all. But if you want them to have one, keep these drawing tips in mind.

MAKE THE NOSE SHORT

Noses grow longer with age. (Sorry about that.) So a cute little button nose is more baby-like.

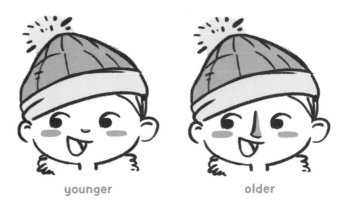

younger older

KEEP THE NOSE CLOSE TO THE EYES

Remember when we squished the face together to create baby proportions? One reason this drawing trick works is because the nose looks shorter and more baby-like when it's closer to the eyes.

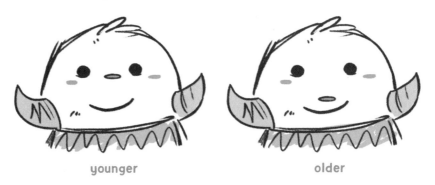

younger older

TRY A TILT

As noses grow longer, some also turn downward. Draw an upturned nose to get a baby-like look, or find the angle that works for you.

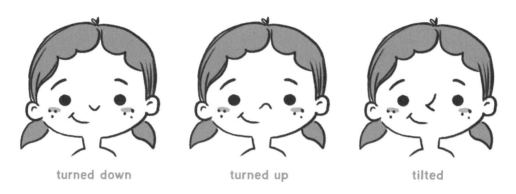

turned down turned up tilted

NO NOSE NECESSARY

If you really want to push how stylized your drawing is, you can make the nose so small, it disappears! Who nose? You might like how it looks!

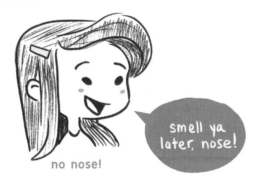

no nose!

smell ya later, nose!

A NOTE ON NOSTRILS

Let's be honest, noses are where boogers go. And that isn't always appealing, even if it's perfectly normal. So bringing attention to things like nostrils can make your drawing look less classically cute (even if they're drawn small).

details not necessary

MOUTH

As one of the most expressive parts of the face, the mouth is a super important feature. Although baby proportions call for drawing a small mouth, the choice is up to you.

BABIES HAVE SMALL MOUTHS

If you're sticking to baby proportions, then a small mouth will look more baby-like. Just remember to keep it close to the nose.

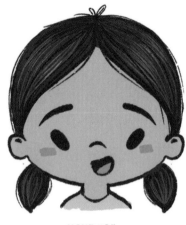

younger

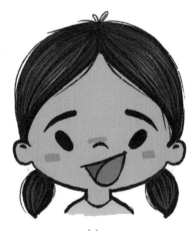

older

...BUT LITTLE MOUTHS ARE LESS EXPRESSIVE

Big mouths are great for expressing big emotions, like enthusiasm or rage. So although big mouths are less baby-like, they are still cute and help us feel emotionally connected to a character.

tip

When designing with a small mouth, you can use the eyes and body to push the emotion instead. See the chapters on expressions and poses to learn more.

EARS

Cute ears can be large, small, or anywhere in between. It's their placement on the head, not just their size, that makes ears cute.

LOWER THE EARS

The ears usually travel with the eyes. So if you move the eyes down, try moving the ears along with them.

older

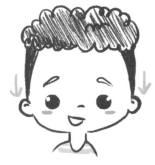

younger

classically cute

little kid cute

PLAY WITH THE SIZE

Sometimes the ears grow faster than the rest of the head. So although small ears are more baby-like, huge ears on a little kid can be just as adorable.

⋛tip⋚

Not sure which facial feature to choose? Decide on a personality for your character first, then choose the features that tell that story.

- SHY
- little kid
- kind

PRACTICE TIME

TRY DIFFERENT . . . EYE SIZES

PUPIL SIZES

NOSE SHAPES

MOUTH SIZES

EAR PLACEMENTS

FREE SPACE TO PRACTICE

proportions of the body

When drawing children or babies, it helps to compare how the child's body differs from the adult body. You'll see differences not just in height, but also in the size of the head, jaw, and other features.

COUNT THE HEADS

The size of the head helps us tell what age a character is. Take a look at this lineup of average proportions and see how many "heads tall" each person is.

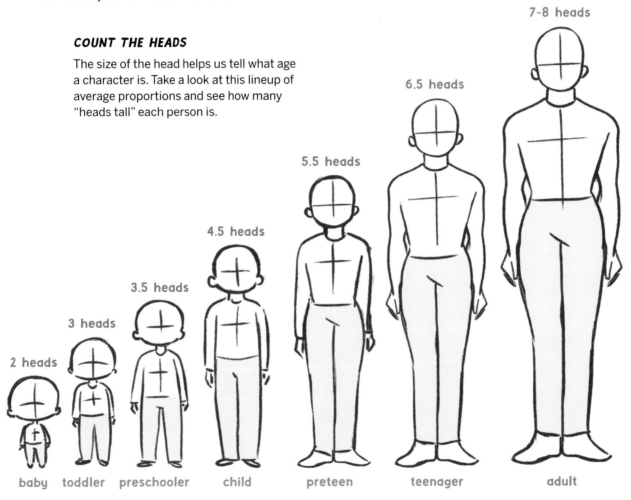

2 heads — baby

3 heads — toddler

3.5 heads — preschooler

4.5 heads — child

5.5 heads — preteen

6.5 heads — teenager

7-8 heads — adult

USE BABY PROPORTIONS

From our lineup on the left, we can see that babies and kids are 2–3 heads tall. By using these proportions, we can quickly make cute characters!

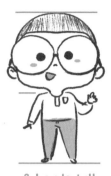

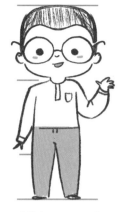

2 heads tall 2.5 heads tall

ADD A LITTLE SQUISHINESS

Little babies keep their baby fat. It keeps them healthy, and it's oh so cute!

HANDS AND FEET

Babies have the cutest lil' hands and feet. Keep that in mind, and you'll be drawing cute characters in no time.

GIVE YOUR CHARACTER TINY HANDS...

An adult's hands are about the same size as their face, but a baby's hands are much smaller.

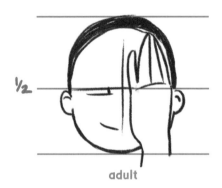

adult

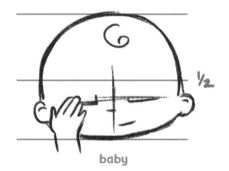

baby

...AND TINY FEET TOO

Just like those cute little hands, small little feet are also adorable.

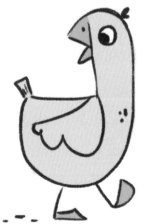

AGE IT UP, BUT KEEP IT CUTE

If you want to draw an older character, you can make them cute by mixing in older features with younger ones.

TWEAK THE PROPORTIONS

By changing up some of your character's features to look older, you can age your character. For example, giving your young character larger ears or feet.

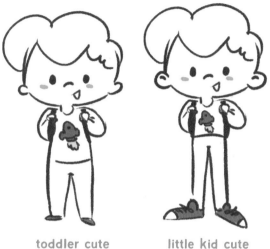

toddler cute little kid cute

ADD DETAILS

By adding details that indicate age, like the clothes they are wearing or the way they stand, you can keep your characters' proportions looking cute—even when drawing different ages.

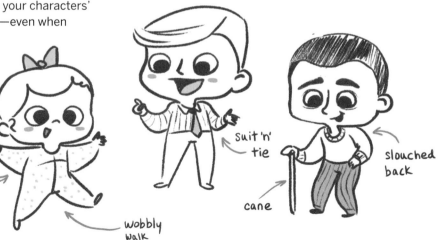

pjs

wobbly walk

suit 'n' tie

cane

slouched back

TROUBLESHOOTING

A common question artists have is why their young character looks older than they intended. I've found this is often caused by adding too many details. Try simplifying your design to make it cuter.

LESS IS MORE

Adding a pokey chin, nostrils, lines around the eyes, and other similar details can age up your character. To keep things baby-like, be thoughtful about what details you add. When in doubt, keep it simple.

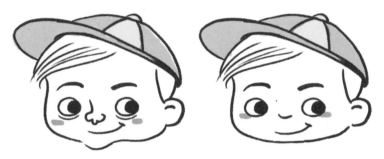

ERASE THE SKETCH LAYER

Although I love to see my sketch under the final drawing, stray lines near your character's eyes may give the accidental appearance of age. Remove these lines to get back that baby-cute look.

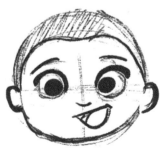

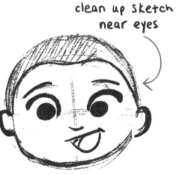

clean up sketch near eyes

make it cuter!

Is your character looking older than you'd like? Check its proportions against all the design tricks we've learned in this chapter. What can you tweak? Keep experimenting to see how small changes make big improvements.

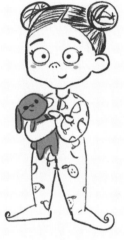

original

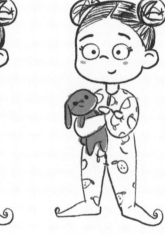

simplify face

ears

feet

smaller features

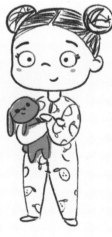

widen face

move eyes, nose, and ears down

larger pupils

PRACTICE TIME ↘

TRY DIFFERENT . . . HEAD SIZES

BODY SHAPES

HAND/FEET SIZES

FREE DRAWING SPACE

- UNLOCKING THE SECRETS OF -
CUTENESS

WHEN I WAS TRAINING ARTISTS, I discovered that there was more to cuteness than just drawing baby-cute features. Which is exciting, because it opens the door to many different styles and ideas about what cute can be. ✦ In the previous chapters, you learned the features that people generally find cute and appealing, but here's the thing—you don't need to use *all* those features when you're building a cute character. And you certainly don't need to find those features cute—*you* get to decide what cute means to you and your art! Let's look at some tools that go beyond the basic baby-cute look. With these tips in hand, you can make *anything* cute.

what else is cute?

The drawing below is adorable! But this character doesn't look like a baby.
So why is it giving us all the feels?

you can be cute at any age!

SHAPES

Pay close attention to how round or pointy your drawing is.

COLOR

Some color palettes will feel cuter than others.

STORYTELLING

Remember that cute things make us feel love and affection. With the right story you can make all the things cute.

CUTE SHAPES

Round shapes feel cute because they seem friendlier and are more pleasant to look at. Sharp edges (like those you see on squares and triangles) are more interesting . . . but also a little more dangerous.

CIRCLES ARE THE CUTEST

A circle is the cutest of the shapes because it has no corners to hurt us with.

sturdy

edgy

friendly

BABY-PROOF SHARP CORNERS

If you want to make other shapes feel friendlier, just soften their corners.

rounded edges feel cuter

⋛tip⋚

When you figure out your unique style of cute, you can choose to use all gentle shapes or a mix of soft and sharp ones.

CUTE COLORS

Picking cute colors is not a one-size-fits-all activity. But in general, bright, light, or happy colors will feel more vibrant, dynamic, and adorable than dark or colorless options.

JUST A LITTLE COLOR GOES A LONG WAY

Even a single pop of color can add a whole lot of cuteness. When picking cute colors, remember that cute things are friendly, pleasing to look at, and make us feel happy.

cute... cuter!

BRIGHT COLORS ARE CUTER THAN DEEP OR DULL COLORS

Light colors remind us of daylight, summer, and happiness.

cute... cuter!

PRACTICE TIME

BREAK OUT THE COLORED PENCILS AND FIND YOUR FAVORITE COLOR COMBOS

WHICH DO YOU LIKE THE BEST?

visual storytelling

A large part of cute art isn't just about *how* you draw and paint. It's also about what you are communicating with it. Your goal is to make the viewer feel a specific emotion. Here are a few storytelling tips and tricks to get those feels flowing.

SHOWCASE HAPPINESS

Showing your character feeling happy or lovey-dovey is a simple way to inspire adorable feelings in others. How can your drawing make other people smile?

PUT TWO CHARACTERS TOGETHER

One of the easiest ways to tell a story is to have two characters interacting. How do they feel about each other? What else do their actions show?

CONTRAST THE EMOTIONS

Put two people into the same situation and give them different reactions. This will instantly give each character a unique personality.

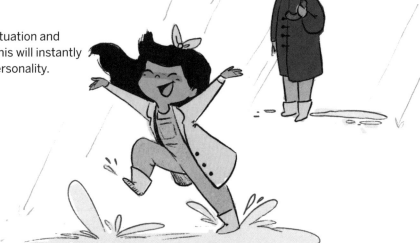

GIVE YOUR CHARACTER A PROP

If you want your character to go solo, give them a prop or a situation to interact with instead. Seeing a character react to something can tell us a lot about their personality.

DRAW THE UNEXPECTED

A child with a stuffed bear is very predictable. By swapping out the toy with something less expected, they become a more unique and interesting character.

DRAW THE **REALLY** UNEXPECTED

Drawing a character who's of a surprising size, in a surprising place, or having a surprising emotional reaction tells a more interesting story.

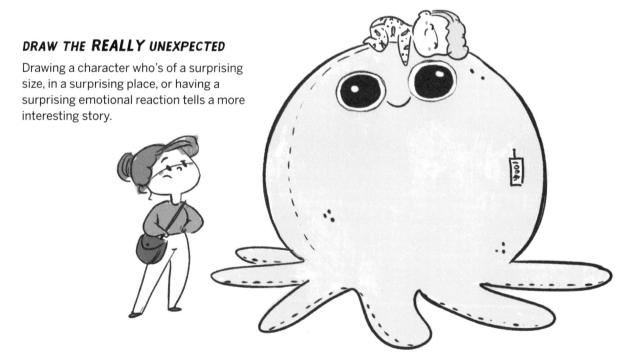

PRACTICE STORYTELLING TRICKS

GIVE GHOSTIE A PROP

GIVE GHOSTIE A FRIEND

GIVE GHOSTIE AN UNEXPECTED PROP

PUT GHOSTIE IN AN UNEXPECTED LOCATION

WHICH DO YOU LIKE THE BEST?

– THE PRINCIPLES OF –
CUTE DESIGN

GOOD DESIGN IS THE KEY TO INTERESTING ART. In this chapter, you'll learn basic design principles that help you create cute and adorable art. ✦ But what is design, anyway? Well, an artist's design is made up of all the lines, shapes, colors, and other elements they choose when making a drawing. These elements let them control and organize the message of their art. ✦ And design choices aren't just useful when drawing characters—you can use them for any kind of visual art. With this chapter (and really, this book) in hand, you'll have everything you need to make the cutest design choices.

elements of design

There are a few key design elements that appear in all areas of visual art. By using these elements, you can control the message you're creating and use it to create more engaging illustrations. I will mainly show examples of character art, but these ideas can be used to make anything cuter—props, backgrounds, or really any other area of art and design.

CONTRAST

Contrast is what you get when you put two very different things together. Without contrast, everything would look the same. People's eyes are attracted to contrast, so by adjusting how different two things look, you can control where someone looks— and how long you keep their attention.

high contrast

low contrast

⋅did you know?⋅

Contrast is important for every aspect of visual design—lines, color, shapes, and even storytelling!

VARIETY

Although contrast is amazing, there is such a thing as too much of a good thing. That's why it's important to add variety to your illustrations—so some parts have a lot of contrast and others don't. By adding variety, you can also draw your audience's eyes to the focal point of your drawing, which is the first place you want them to look.

TOO MUCH VARIETY CREATES CHAOS

Find a balance between contrasting elements and similar elements so your design looks engaging—but not over-busy or chaotic.

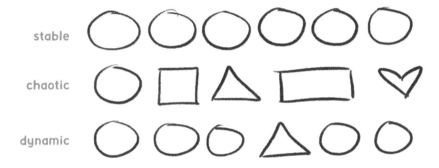

SIMILARITIES CREATE HARMONY

Similar elements will blend together and feel harmonious. For instance, pink and orange play nicely together and look appealing, while blue and orange fight for your attention.

interesting harmonious

CREATE FOCAL POINTS

By mixing areas of harmony with an area of contrast, you're creating a focal point. Now you can control where someone will look!

focal point

VALUE

Value is how artists describe how light or dark something is. Dark areas against white areas create lots of contrast. If the shades of black, white, and gray are too close together, it can be hard to understand or even see the image.

USE VALUE TO CREATE CONTRAST

An area of light surrounded by an area of dark creates a focal point. But remember that the opposite is also true! Which of these girls draws your attention?

little value contrast lots of value contrast

all angles some curves

LINE

Lines are the primary tool we use while drawing. By adjusting the types of lines you use, you can create movement and interest.

TRY STRAIGHTS AND CURVES

Curves are friendly, sure. But if we only used round shapes in our drawings, there would be no variety. Mixing things up creates more interesting illustrations.

SHAPES

Adjust the kinds of shapes you're using in your illustration to communicate different emotions.

SHAPES TELL A STORY

Triangles are dangerous, squares are stable, and circles are friendly.

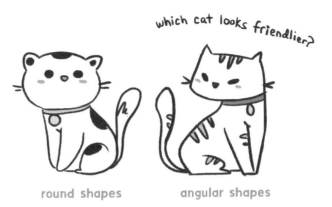

which cat looks friendlier?

round shapes angular shapes

SIZE

Check the size of individual objects in your design and look for variety. Contrast in sizes can be used to create focal points and create engaging designs.

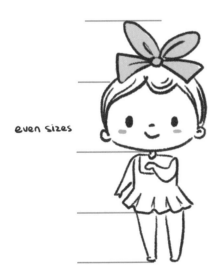

even sizes

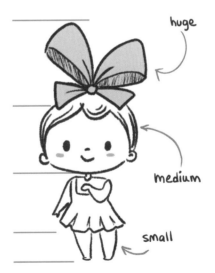

huge

medium

small

SPACING

Early on in our artistic journey, it is common to place objects or details evenly across the page. This makes an image look orderly and clean, but also unnatural.

UNEVEN SPACING IS ORGANIC

Balanced or even spacing feels machine-made. Meanwhile, uneven, unbalanced spacing feels handmade or organic and makes your art feel more alive.

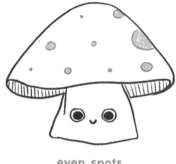

even spots uneven spots

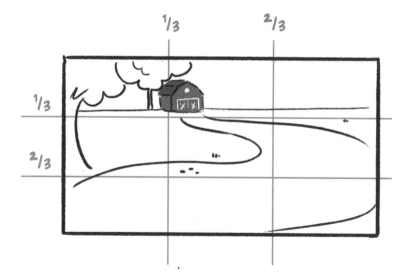

USE THE RULE OF THIRDS

The rule of thirds is a trick used by artists to ensure they have uneven spacing in their images. To use it, divide your drawing area into thirds and place the focal point where the lines cross. Now that looks nice!

THE RULE OF THIRDS: FACE EDITION!

Remember when we played with cute proportions and discovered that characters looked cutest when we placed their features at the bottom of their face? These cuties are representing the rule of thirds *and* great design.

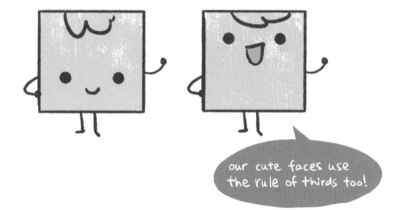

our cute faces use the rule of thirds too!

DETAIL OR TEXTURE

By adjusting the amount of detail in your illustration, you can make some areas feel dense and other areas open. Leaving some areas untouched gives your eye a place to rest.

added details

tip

Freckles, glasses, and other features don't just add texture and detail to your drawings—they also give your characters more personality!

COLOR

Color is a key element in creating cute art. Whether you choose to use a lot or a little, basic color theory will help you on your journey.

ADD ANY COLOR TO MAKE IT POP

Adding one color to a black-and-white image creates a focal point.

FOR THE BIGGEST POP, MAKE IT RED

Of all the colors, red is the most eye-catching. That is why stop signs are red!

THE ODD COLOR STANDS OUT

If you're working on an image that's mainly orange and pink already, red will *not* pop because it's too similar to its surroundings. In this case, try a cool color instead.

≷tip≷

Be careful where you place red in your designs. If you put red somewhere that isn't your main focus, you might distract your viewer.

WARM OR VIBRANT COLORS DRAW THE EYE

Warm colors, such as red, pink, orange, and yellow, are more eye-catching than cool colors, like blue and green.

⁊did you know?⁊

When we talk about how bright colors are, we say that vibrant colors are "saturated" and dull colors are "desaturated."

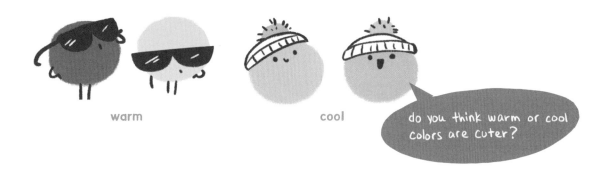

warm cool

do you think warm or cool colors are cuter?

VIBRANT COLORS STAND OUT

Bright shades stand out, but if *everything* stood out you'd have nothing to focus on. Dull colors give your eyes a place to rest. Every color has its place—and plays its part!

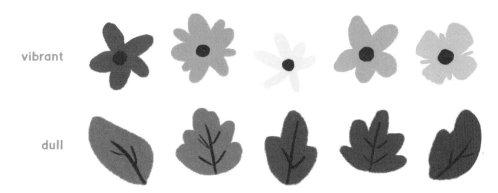

vibrant

dull

PRACTICE TIME

DRAW FACES USING DIFFERENT . . .

VALUES

LINES

SHAPES

SIZING

SPACING

DETAILS

COLORS

COMBINE YOUR FAVORITES

PRACTICE TIME ↘ DRAW AN OBJECT OR A CHARACTER WITH DIFFERENT . . .

VALUES

LINES

SHAPES

SIZING

SPACING

DETAILS

COLORS

COMBINE YOUR FAVORITES

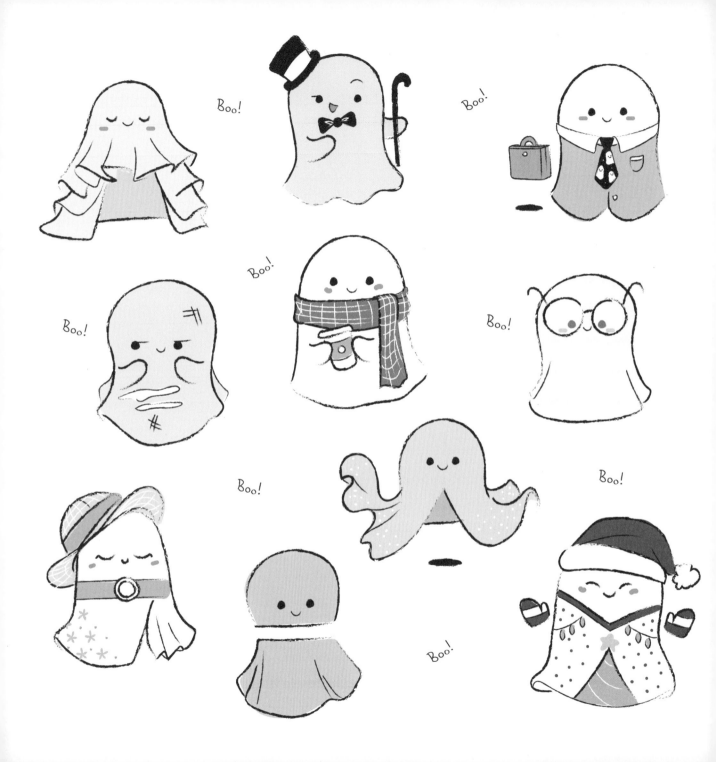

- DEVELOPING YOUR OWN -
CUTE STYLE

YOU DON'T HAVE TO DRAW BABY CUTE TO DRAW CUTE STUFF. In fact, if everyone drew all the same cute traits, there would be no variety, and cute art would become super boring. ✦ By picking and choosing which features you'd like to add and deciding just how classically cute you want your art to be, you can perfect a style of cute that's yours—and only yours! I can't wait to see how you decide to define cuteness.

THE CHOICE IS YOURS

Babies are cute, but now it's your choice to decide how baby cute you want your style to be.

APPLY BABY TRAITS...

The closer your character's proportions match a baby's, the more classically cute your art will look.

Head size
It's okay to be a little top heavy.

Vibrant color
Bright pastels are the cutest of the cute colors.

Happy face
Happy faces make us feel happy.

Gigantic eyes
Big ol' pupils, please!

Round shapes
Curvy shapes feel so friendly.

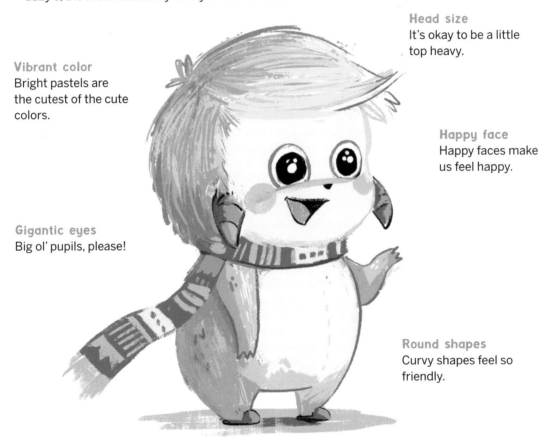

...OR REMOVE BABY TRAITS

Just because babies are the cutest doesn't mean *everything* you draw has to be a baby. Remove some babyish features and decide what level of cute is right for *you*. This is how I'd tweak a classically cute style to create my own personal style.

Head size
Two and a half heads tall—just a tad less cute.

Mixed color
I love a mix of bright and dull colors.

i'm still cute!

Expressive
Happy faces are cute, but I love to use the full range of emotions.

Storytelling
Yeti has a cute bunny friend. I want to love them both.

Mix shapes
I like to mix mostly round shapes with some sharp shapes for variety.

PLAY WITH SHAPES

Cute comes in all shapes and sizes. Although circles are cute, they can also be a bit bland. When creating your own style, see if you like mixing it up!

WHAT'S YOUR SHAPE LANGUAGE?

When you use the same types of shapes over and over—like round shapes or sharp shapes—you start to figure out the overall style of your artwork. Which shapes do you like to use?

round shapes

angular shapes

MIX AND MATCH SHAPES FOR CONTRAST

Try giving your character fewer round shapes and more sharp edges to make them more interesting. Experiment and see how different shapes suggest different personality traits.

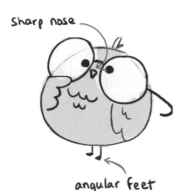

Sharp nose

angular feet

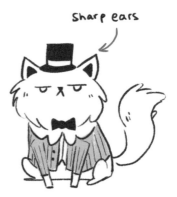

Sharp ears

square legs and hat

PRACTICE TIME ↘

USE A VARIETY OF SHAPES TO DRAW A CUTE BIRD

WHICH DO YOU LIKE THE BEST?

redefine cuteness

You may have noticed earlier I used the words "less cute" or "cuter" to label or describe things. I did that so you can choose for yourself just how cute you'd like to go with your style. Since what we think is cute is subjective, this is your chance as an artist to explore and create new standards of cuteness.

CUTE COMES IN ALL AGES

Don't be afraid to draw older characters! Super baby-cute characters get a lot of attention, so why not throw some love toward all the people?

i think we're both cute!

lopsided eyes

EMBRACE IMPERFECTIONS

Nobody's perfect, so your characters don't have to be either. Try leaving imperfections in your drawing or adding in less "classically cute" features to create some uniquely adorable characters.

undereye lines

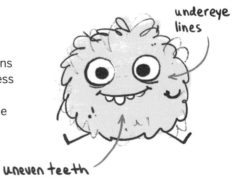

uneven teeth

make it cuter!

Did you push your drawing too far and want to bring some cuteness back? Just layer the cute features back in until you find the level of cuteness that you love. Every character you create might have a different amount of cuteness. Keep experimenting as you find your personal style.

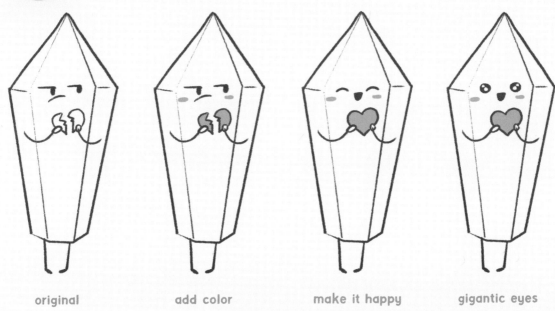

original add color make it happy gigantic eyes

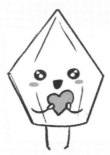

≥tip≤

Keeping your story in mind is key. In this example, making my character with round shapes and a giant head would make it feel like a baby—which I didn't want for my story. So I only applied the cute traits that would help tell my story and left the other ones out.

find your favorite traits

A great way to create your own unique style is by looking at lots and lots of other art! Think about what you like from the styles you've seen and combine them in your own way. The following pages offer some cute styles for you to explore for your adorable characters, but the options are endless. It's time to develop your own style!

STEP 1 CHOOSE AN EYE SHAPE

Choose from the list on the facing page or add your own.

STEP 2 CHOOSE A NOSE SHAPE

Choose one from the list on page 90. Try using one you haven't done before!

STEP 3 CHOOSE A MOUTH SHAPE

Choose one from the list on page 91. Trying different styles helps you discover what you do and don't like.

What else can you stylize?

From the face and body shape to the ears and toes, all parts of the body can be adjusted to fit your style. In fact, anything you draw can be stylized. Finding a set of shapes you like to draw with is how you start to create your own style.

EYE STYLES

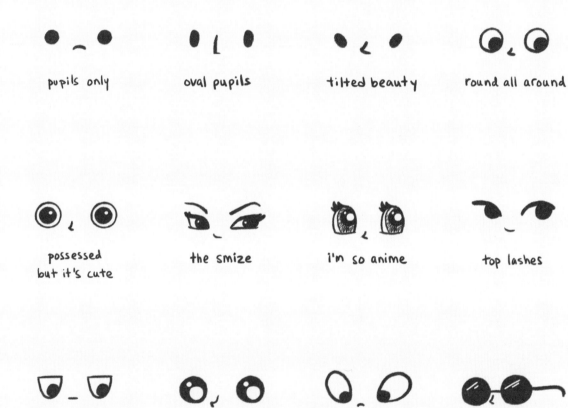

pupils only

oval pupils

tilted beauty

round all around

possessed but it's cute

the smize

i'm so anime

top lashes

flat on top

glitter balls

cutey-patootie

suspiciously reflective glasses

NOSE STYLES

simple shapes

filled shapes

add a bridge

nostril time

MOUTH STYLES

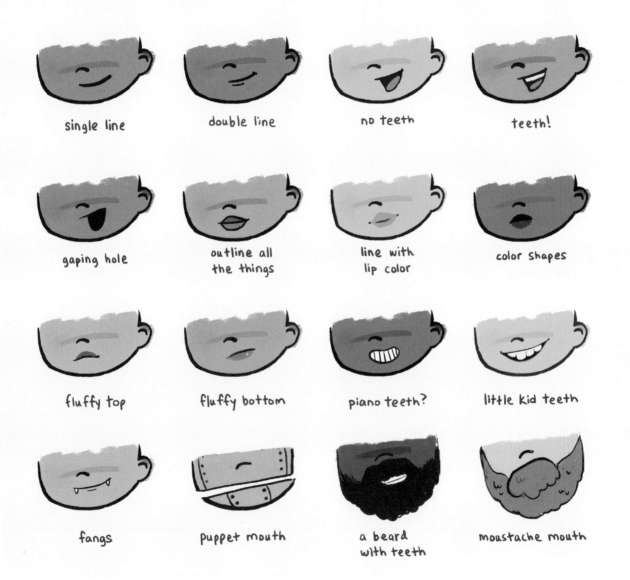

single line

double line

no teeth

teeth!

gaping hole

outline all
the things

line with
lip color

color shapes

fluffy top

fluffy bottom

piano teeth?

little kid teeth

fangs

puppet mouth

a beard
with teeth

moustache mouth

PRACTICE TIME ↘

TRY SOME DIFFERENT...EYE SHAPES

MOUTH SHAPES

NOSE SHAPES

WHAT COMBO DO YOU LIKE BEST?

USING JUST THE FACE, PLAY WITH SOME CUTE STYLES

BABY CUTE

REMOVE A FEW CUTE TRAITS

ADD SOME NOT-CUTE TRAITS

WHAT LEVEL OF CUTENESS DO YOU LIKE?

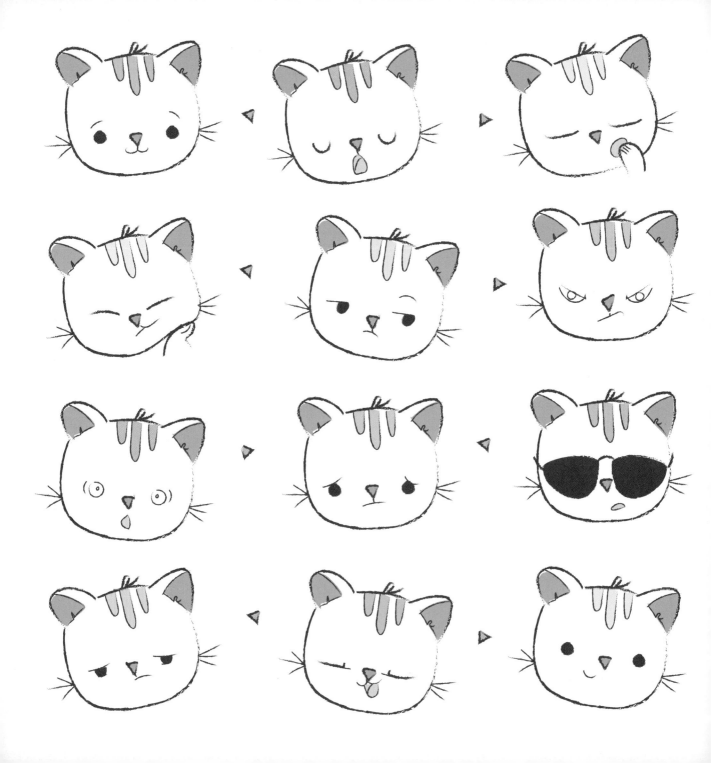

- HOW TO DRAW ADORABLE -
EXPRESSIONS

A LARGE PART OF CUTE ART is creating an emotional connection. When going for a classically cute look, you can always just draw a happy face or a big-eyed baby, but to truly tell a character's story you need to draw the full range of human emotions. A slight shift of an eyebrow or a twitch of the mouth can change how your character feels and the message you're sending about it. ✦ In this chapter, you'll learn how each part of the face plays a role in showing your character's emotions.

the five basic emotions

The range of human emotions is limitless! But if you understand how the five basic emotions—neutral, happy, sad, angry, and shocked—are expressed through the face and body, you can build on to those feels to create the right expression for every moment.

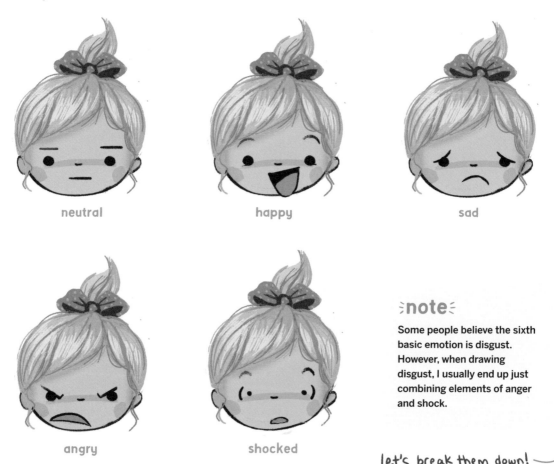

neutral

happy

sad

angry

shocked

≷note≷

Some people believe the sixth basic emotion is disgust. However, when drawing disgust, I usually end up just combining elements of anger and shock.

let's break them down! ⟶

SIX KEY INDICATORS OF EXPRESSION

There are six key indicators of expression on the face. When you adjust these features, you can create all sorts of emotions and expressions. Make sure to keep a look out for how they change as we explore the five basic expressions. The six key indicators are:

Eyebrows
Watch for their shape and their location on the face.

Nose
The nose may move when the mouth comes up.

Pupils
The size of the pupils gets larger and smaller.

Tilt of the head
Tilting to the side or looking up or down.

Eyelids
Although the upper eyelids follow the eyebrows, the lower eyelids move independently.

Mouth
Look at the shape of the mouth and its location on the face.

Use every part of a character to push the expression

You can use other features around the head including hair, props, or ears to show the expression as well!

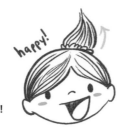
happy!

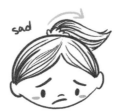
sad

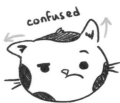
confused

NEUTRAL

A neutral expression is usually made up of straight lines. We don't usually think of "neutral" as an emotion, but it is. And better yet, it serves as a blank canvas on which to create all sorts of other emotions.

neutral eyebrows

mouth straight or missing

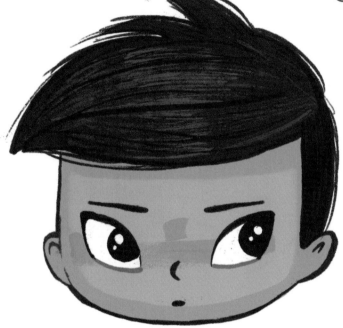

⊰ tip ⊱

The neutral emotion can range from bored to sleepy or even just unamused. Try removing the mouth or eyebrows altogether and see what happens!

no brows

no mouth

CURVE THE EYES UP OR DOWN

Even a toddler can tell you that when a character has eyelids that point downward, it means the character is nice and relaxed (or going night-night). Meanwhile, eyelids that point up are happy eyes!

tired

happy

CONTROL THE MOUTH

Sometimes, a person's face looks neutral because they're holding back their feelings. Draw the mouth small or pressed thin to show your character trying to keep it together.

subtle emotion

held-back emotion

UNFOCUSED EYES FLOAT

A neutral expression with floaty eyes suggests that a character's mind is wandering. You should be able to see the whites of the eyes around the pupils . . . hmm, what do you think they're thinking?

floaty eyes

⋚caution⋚

Don't make the pupils too small unless you want the character to look scared!

HAPPY

The happy face is most characterized by that smile we all know and love. It is generally an open and free expression with lots of energy.

relaxed eyebrows

lips pull back
mouth may opens

⟩tip⟨

To push this emotion, try adjusting the bottom eyelids. When someone is smiling sincerely, their bottom lids push up on their eyes and their eyes squish together. If the bottom lids don't come up, it can make the smile look fake!

SMILE WITH THE MOUTH

When it comes to showing happiness, the mouth is key. The happier your character feels, the larger and more open their smile looks.

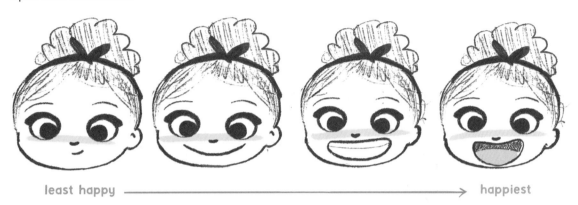

least happy ⟶ happiest

SMILE WITH THE EYES

Artists often forget that in a true smile, the eyes also change. Here are some ways to adjust the shape of the eyes to show that your character is genuinely joyful.

 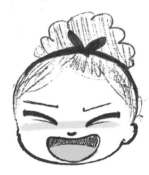

lift lower lids up enlarge pupils close the eyes

SAD

Besides the most obvious signs of sadness (the waterworks!), you can tell a character is sad because of the classic frown and pout. Let's just say it's the visual opposite of all things happy.

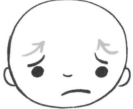

eyebrows squish together

lip corners pull down

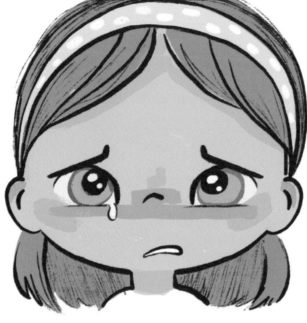

⩔ tip ⩔

Draw with soft edges and curves when drawing a sad character. Sharp angles can look more like anger than sorrow.

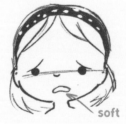

soft

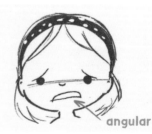

angular

HOLD BACK THE EMOTION

Tell a story with different levels of emotion! Unless your character is very young (or not great at holding back their feelings), they may try to hide their sadness—before bursting into tears.

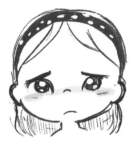 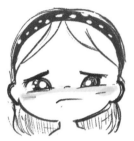 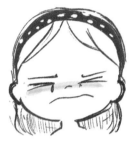 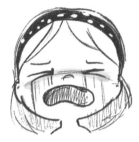

lip corners
curve down

eyes and mouth
squish together

eyes and mouth
squishes closed

mouth opens
with waterworks

USE A WIDER MOUTH

A narrow mouth tends to communicate surprise or shock, so keep the mouth wide if you're trying to make a character look bummed out.

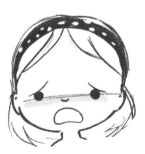 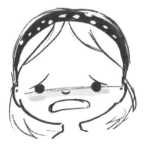

more surprised

more sad

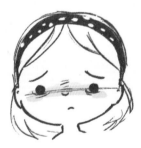

⸗tip⸗

Adding a bit of wear and tear on the face (like darkness or bags around and under the eyes) can make it look like a character has been crying.

ANGRY

Grr! If you've ever felt angry, you know that this emotion is **intense.** Avoid using soft curves—and keep your lines sharp—so the energy of your drawing matches that intensity.

eyebrows point in and down

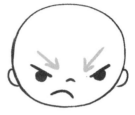

keep mouth sharp

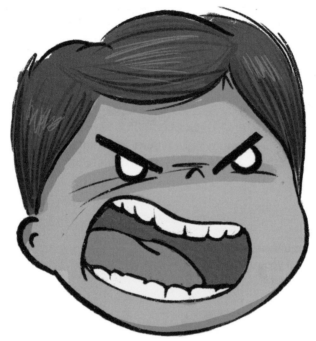

≷tip≷

Anger is more of a "sharp" emotion. So the more jagged or angular your drawing, the angrier your character will feel.

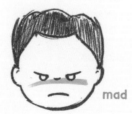

mad

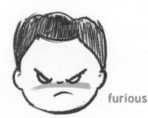

furious

STARE DOWN THE ENEMY

When a character is just starting to feel upset, they might look away. But when they're *really* angry, they'll often look directly at their enemy with a cold, hard stare.

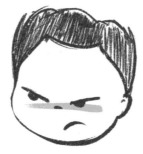

annoyed

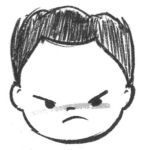

angry

ADJUST THE PUPILS

In anger, the eyes get wider and we see more of the whites of the eyes around the pupil. In drawing, you can exaggerate this by removing the pupils. You can even draw your character with hyperfocused eyes to show they mean business!

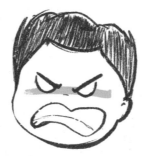

eyes dilated

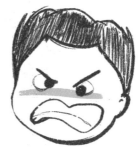

hyperfocused eyes

SHOW MORE TEETH

When someone is angry, the mouth can change from a frown to a grimace, and finally to an open-mouth scream.

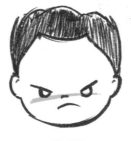

angry

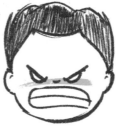

angrier

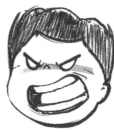

angriest

SHOCKED

This expression tells us, "I wasn't expecting that!" A shocked face often has wide eyes and a mouth that's narrow and open.

eyebrows up

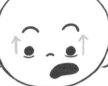

open mouth and wide eyes

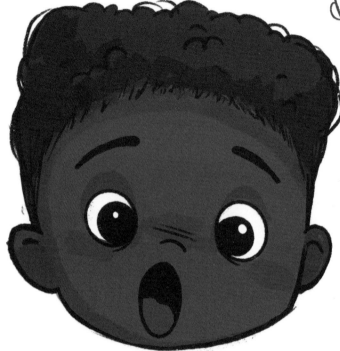

⟩tip⟨

Shock is the expression someone has in the moment before they know how to feel about what's just happened. So the eyebrows and mouth can look pretty neutral when someone's first shocked or surprised.

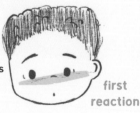
first reaction

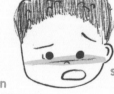
secondary reaction

MAKE IT A WIDE-EYED STARE

The first sign of surprise is often a wide-eyed stare. To show this, you can open your character's eyes up or widen them side to side.

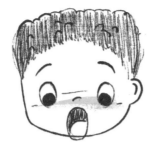 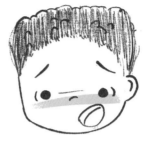

eyes open up eyes open wide

DILATE THE PUPILS

The pupils get smaller when surprise turns to fear. If you want to exaggerate this in your drawing, you can even make them disappear!

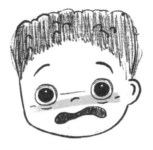 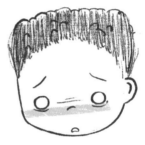

fear terror

TWEAK THE EMOTION

If you keep the eyes wide, the mouth and brows can be used to change the emotion. Tweak the mouth and brows to show the difference between a happy surprise and a horrible shock.

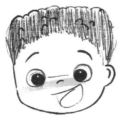

surprised afraid appalled

drawing complex emotions

In life, we often experience more than one emotion at a time. So our adorable—
and adorably lifelike—characters should too! Combine any two of the five main
expressions to create deeper emotional reactions in your characters.

MIX UP THE EYES AND MOUTH FOR COMPLEXITY

Combine the eyes of one emotion with the mouth of another
to create a new, deeper, or more complex emotion.

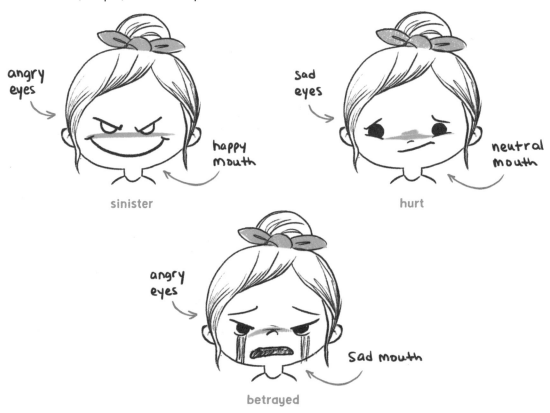

angry eyes

happy mouth

sinister

sad eyes

neutral mouth

hurt

angry eyes

sad mouth

betrayed

SOFTEN THE LINES TO SOFTEN THE EMOTION

By slightly softening or sharpening the facial features, you can add just a hint of another emotion to the expression.

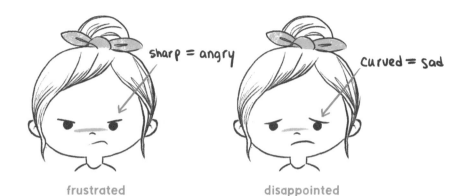

sharp = angry

curved = sad

frustrated

disappointed

MIX IT UP FOR CONFUSED FACES

You can show confusion by drawing one eyebrow up and one down. Then use the mouth to tell your audience whether your character likes being confused or not.

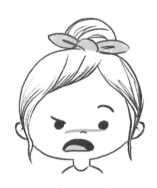

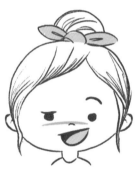

disgusted

bemused

⊰ tip ⊱

Combine features in any way you want to create some seriously silly faces. How mixed up can you make them?

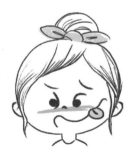

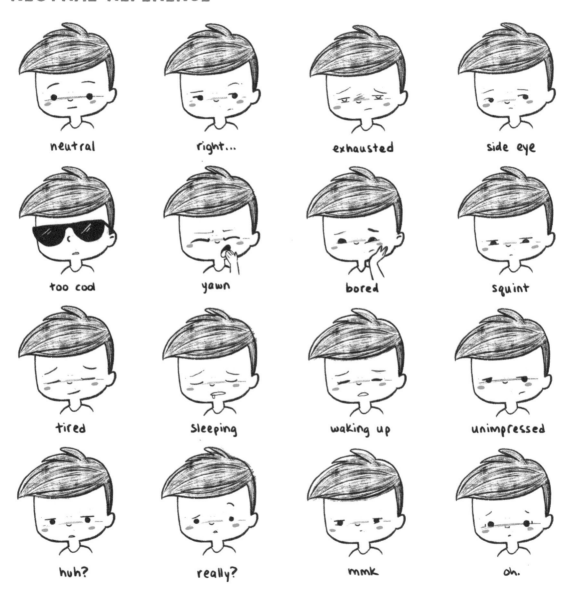

neutral

right...

exhausted

side eye

too cool

yawn

bored

squint

tired

sleeping

waking up

unimpressed

huh?

really?

mmk

oh.

HAPPY REFERENCE

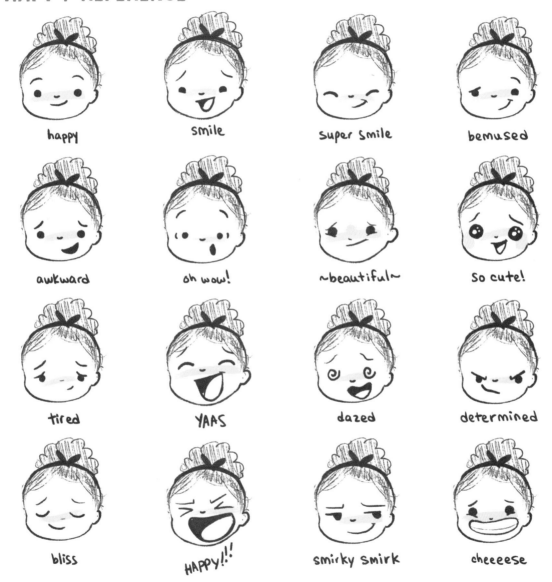

happy

smile

super smile

bemused

awkward

oh wow!

~beautiful~

so cute!

tired

YAAS

dazed

determined

bliss

HAPPY!!!

smirky smirk

cheeeese

SAD REFERENCE

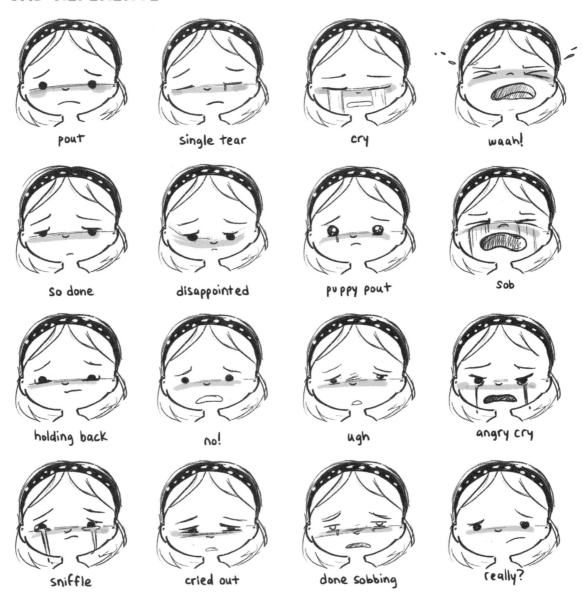

pout

single tear

cry

waah!

so done

disappointed

puppy pout

sob

holding back

no!

ugh

angry cry

sniffle

cried out

done sobbing

really?

ANGRY REFERENCE

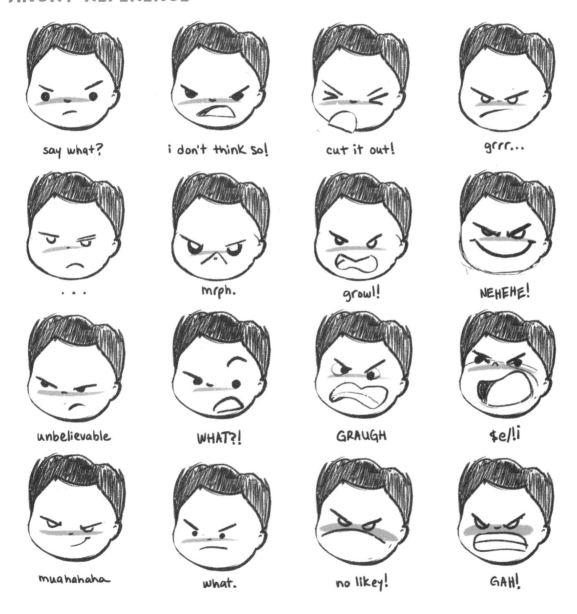

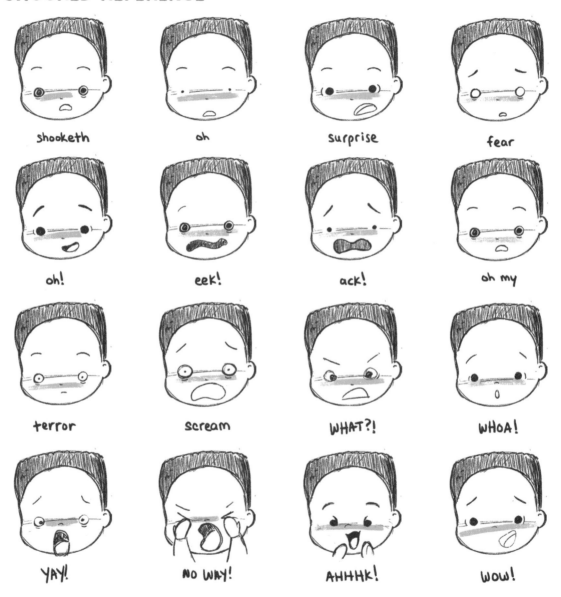

shooketh

oh

surprise

fear

oh!

eek!

ack!

oh my

terror

scream

WHAT?!

WHOA!

YAY!

NO WAY!

AHHHK!

WOW!

COMPLEX EMOTIONS REFERENCE

PRACTICE TIME — *TRY DRAWING SOME EMOTIONS*

NEUTRAL

HAPPY

SAD

ANGRY

SHOCKED

CONFUSED

SILLY

COMPLEX EMOTIONS

- HOW TO CREATE ADORABLE -
POSES

KNOWING HOW TO POSE A CHARACTER is an essential skill for any-
one who wants to draw humans, animals, or even humanlike objects.
Although some anatomy know-how is helpful, you can draw cute
characters even with a super-simplistic drawing style. ✦ This chapter
focuses on how to start drawing your first humanlike bodies—and the
sassy, serious, and silly poses that bring them to life. You'll also learn
how to use body language to push the expression even further, because
although the face tells you a lot about a person's feelings, the body can
tell an even bigger story.

what's in a pose?

The way your character positions their body is called a pose. (Get it, *pose*-isition?)

POSES TELL A STORY

They may not contain many details, but it's still clear that these characters are three different people—just by the way they hold their bodies.

POSES SHARE AN EMOTION

These poses also show us how the characters are feeling and behaving right now. Even without a face!

fearful and
untrustworthy

calmly prim
and proper

giddy and
expressive

now learn how to
do it yourself! →

GESTURE DRAWING

Gesture drawing is what artists call their rough drawings when sketching a pose. These sketches are done quickly to get a sense of the character's emotions and body position. At this stage it's okay to make the pose more dramatic than it might be in real life—it's much easier to dial back an overly expressive pose than it is to add energy to a stiff pose.

KEEP IT SIMPLE, KEEP IT ROUGH!

Don't worry about details or proportions during the early stages of drawing a pose. You can add those later. For now, keep things loosey-goosey and focus on getting the emotions and body positions jusssst right.

THE LINE OF ACTION

Many artists like to use the line of action as their first step in drawing a pose. The line of action is usually a single line that shows the energy or emotion of the character—and is a great base to build on! In some poses, I like to add the head first and then the line of action. It's okay to be flexible!

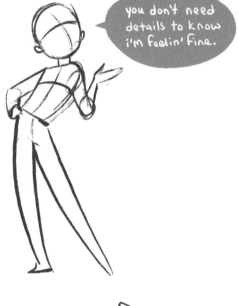

you don't need details to know i'm feelin' fine.

line first

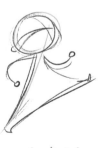

rough sketch

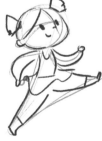

clean

body language

Although many artists focus on the face when expressing a character's emotion, body language is just as, if not more, important when it comes to showing how a character feels. Using the line of action, we can break down the five basic emotions into poses—making sure your character is expressing the correct feeling or attitude with their whole body before adding any other details.

NEUTRAL

The body in a neutral position tends to look relaxed and open. The line of action is normally loose, but can also be stiff, like with a guard standing at attention.

FEELING BORED

A common neutral expression is boredom. A bored character might look upward into the clouds, daydreaming away.

daydreaming thinking

HAPPY

A character who is happy might gaze upward.
They'll look openly expressive and their stance
may seem relaxed or confident,

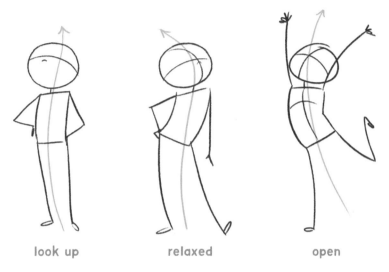

look up relaxed open

FEELING SHY

Usually happy expressions point
upward, but if a character is trying
to hold back their emotion (out of
shyness or otherwise), they may tilt
their head down or look away. Keep
the body pointing up and the head
down to show this complex emotion.

holding back expressing freely

SAD

The line of action in a sad pose tends to point downward, and the character might pull their limbs inward. There is often a sense of weakness or defeat—so no sharp lines here.

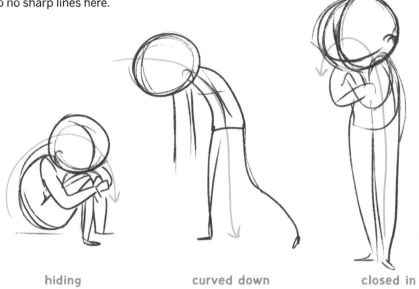

hiding curved down closed in

TWEAK THE TILT OF THE HEAD

If a sad character is looking up, they might be looking for sympathy—or are no longer able to hold in their emotions.

remorseful wants sympathy despair

ANGRY

Angry people are often in attack mode! The lines of their bodies may look sharp, pointy, and full of dangerous angles—or still and solid like a wall. Unlike sad poses, you'll want to keep your lines sharp.

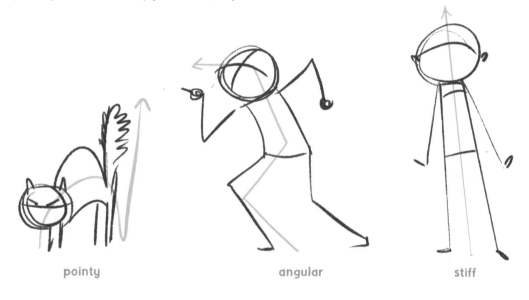

pointy angular stiff

COMPRESS IN, THEN SHOOT OUT

When a character is trying to hold their anger in, their body might look scrunched up and compressed. When they finally release their rage, it can be very sudden and explosive.

holding it in

exploding

SHOCK

When we broke this emotion down in the expressions chapter, there was not a large difference between fear and surprise on the face, but body language tells us a very different story.

SURPRISE POPS UP

Surprise tends to be fast and quick, so there are more straight lines in a surprised pose.

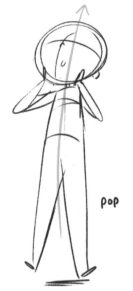

pop

≷ tip ≷

You can help show this sudden and speedy emotion with motion lines!

FEAR TRIES TO HIDE

A character who's afraid may back away or cower from what's scaring them. You can draw a fearful character with their head turned away or bring their limbs inward. The line of action should look weak or wobbly.

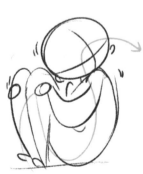

limbs tucked in

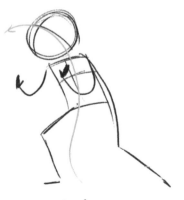

backs away

COMPLEX EMOTIONS

Just like our facial expressions, our body language can
show a wide mix of complicated feelings.

CONFUSION IS MIXED UP

A character with a confused look on their face might
have one eyebrow up and one down. Similarly, a
confused character might be tilting their head
quizzically, with one arm up and one down.

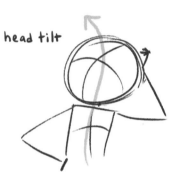

head tilt

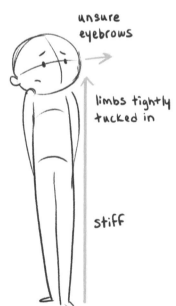

unsure
eyebrows

limbs tightly
tucked in

stiff

nervous

COMBINE EMOTIONS

By combining different bits from the five basic
emotions, you can show complex emotions in
your character.

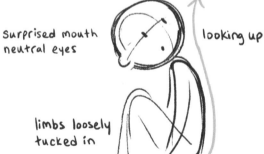

surprised mouth
neutral eyes

looking up

limbs loosely
tucked in

hopeful

> **⋛ tip ⋚**
>
> To create more interesting
> characters, think about
> how you can layer more
> than one emotion at a
> time into your poses.

poses made easy

Poses don't have to be complex! Here are some tips to help keep your poses simple and easy to understand.

USE A STICK FIGURE

You don't need perfect anatomy to draw cute characters! Knowing how to draw a simple stick figure will get you a lot further than you might think. Just pick a stick figure style that works for you.

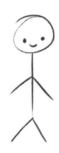

standard

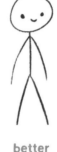

better proportions

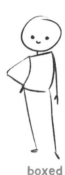

boxed

CREATE A PERSON

If you use the boxed stick figure, you can add just a few more lines to make limbs, hair, and clothing. With just a bit of cleanup, you've created a simple character!

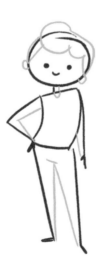

CREATE ASYMMETRY

Look at how you're sitting right now. Is your body in the same position on both sides? Probably not! That's because people usually position their bodies unevenly. Using asymmetry in your sketches can help loosen up the pose and make it feel more natural.

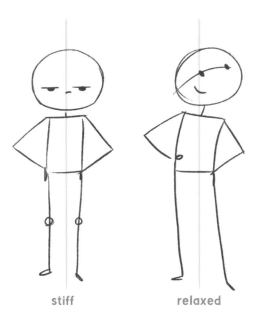

stiff relaxed

CLARIFY THE SILHOUETTE

Fill your drawing in with black. The new shape you've made is called a silhouette. If you can understand what is happening in a pose just by the silhouette, then you know your poses will read clearly.

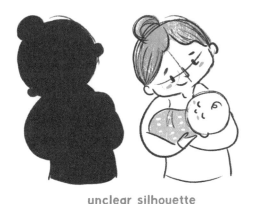

unclear silhouette

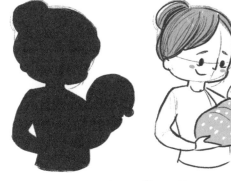

clear silhouette

USING ELLIPSES

Ellipse is a word that artists use to describe how a circular shape changes its shape as it turns away from you. Ellipses are super helpful when drawing poses—but especially when drawing the head.

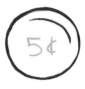

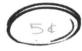
turning up

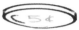

THE CIRCLE FLATTENS OUT

Imagine you're looking at a coin lying flat on a table. It's shaped like a full circle, right? But if you pick the coin up and tilt it around, it'll go from looking like a circle to looking flatter and flatter . . . This distortion of the circle as it moves is what we are going to call an ellipse.

 ← flat

turning down

THE ELLIPSE CREATES VOLUME

When you add ellipses to a circle, it creates the illusion of volume!

It's kind of like a glass ball with a seam on it!

flat circle

sphere

USE ELLIPSES TO PLACE THE EYES, EARS, AND NOSE

Now that you have these handy little ellipses as guidelines, you can use them to keep track of all the parts of the face—even as the head turns.

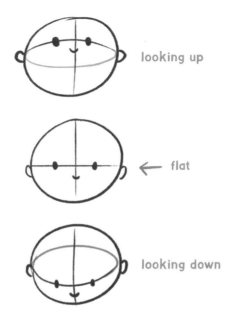

looking up

← flat

looking down

. . . AND ANYWHERE ELSE YOU WANT TO ADD VOLUME

In fact, you can use these amazing ellipses to add bulk and volume to any round object—on a character's body or otherwise!

PRACTICE TIME

USING THE LINE OF ACTION, DRAW SOMEONE . . .

NEUTRAL

HAPPY

SURPRISED

FEARFUL

SAD

ANGRY

MIXED EMOTIONS

≷ **tip** ≶

If you're having trouble getting a pose to work, try acting it out. Or grab a friend and take some photos to use as visual references for your character's action.

PRACTICE TIME

USING STICK FIGURES, DRAW SOMEONE . . .

HOLDING A PINEAPPLE DRINKING WATER WAITING FOR THE BUS

WALKING SADLY SUNBATHING POSING LIKE A MODEL

NOW FILL YOUR POSES IN TO
CHECK YOUR SILHOUETTES! ARE
THE POSES STILL CLEAR?

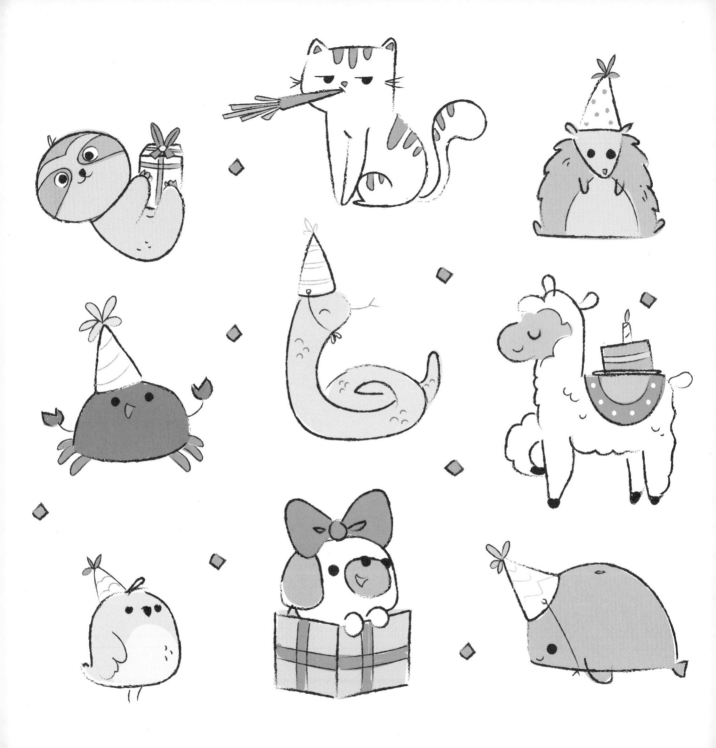

- HOW TO DRAW ADORABLE -
ANIMALS

THERE ARE SO MANY ANIMALS ON THE PLANET, I couldn't possibly teach you how to draw all of them. But as long as you're able to recognize the key features of an animal and draw it using simple shapes, you can draw any animal you'd like. ✦ In this chapter, I'll share some simple tips for drawing some adorable everyday animals, but when it's time to draw on your own, I recommend finding photos of the animal you choose so you can study it and learn what makes it special.

let's draw a snake!

When learning something new, it's best to start with the easiest, simplest steps. So before we lean into more complex animals, let's draw an animal that is basically just squiggles on the page: a snake.

FIND THE ANIMAL'S KEY FEATURES

Think about the most important physical features that make up your animal. Before looking at a picture, what comes to mind when you think of a snake? Write those details down or try drawing them out. For example, when I think of a snake, I imagine a long, winding body, scales, and a forked tongue.

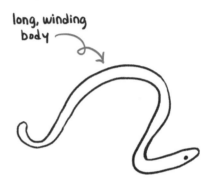

PRIORITIZE UNIQUE ELEMENTS

You don't have to show *all* of the features that make up the animal you're illustrating, but drawing some of its more unique details will help your audience recognize the animal.

I'd say a snake's most unique feature is its long body, and its scales are maybe the least unique feature. That means I can get away with not showing the scales at all, but if I don't draw a long, winding body, I'll have to add a lot more snakey details to make my snake look like, well, a snake. I'll show you what I mean.

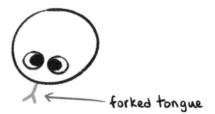

This snake looks like a snake, thanks to its long, slithery body. Adding more key features makes it look even more like a snake, but it's not totally necessary.

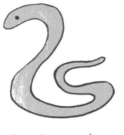

already a snake

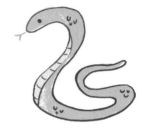

nice details

If I take away the long body, I can still make my drawing look like a snake—I just have to add in the other features to do it.

definitely not a snake

it's a snake!

≳tip≲

Once you've added enough key features to make your drawing look like the animal it's supposed to be, you can add any other features you want—like tiny little legs!

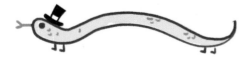

let's draw a fish!

Another simple animal to draw is . . . a swishy little fish! This is a great opportunity to practice using interesting shapes for your character design. Plus, fish don't even have legs. You can handle this!

FIND THE KEY FEATURES

Fish come in all sorts of shapes, sizes, and features, but most tend to have round eyes, fins, and scales.

fins and tail

round beady eyes

scales again!

STYLIZE THE SHAPES

Since fish come in so many shapes and sizes anyway, you can choose any shapes you want—just add some key features to make your fish, well, *fishy.*

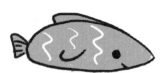

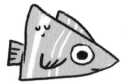

make it cuter!

You've learned how to simplify your animal down to its basic features—to make it easier to recognize. But those features may not always be what'll make your character look the cutest. Break out some of the design tricks you learned earlier in the book to make your animal art even more adorable!

KEEP THE SHAPES SIMPLE

You don't need a lot of detail—or even a lot of lines—to create adorable art. The right level of detail will ultimately be up to your personal style, but in general, keeping it simple keeps it cute.

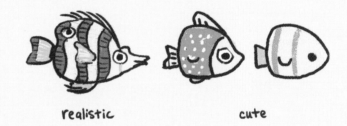

realistic cute

even sizes

CREATE CONTRAST WITH SHAPES

Try making one part of your animal small, one medium, and one huge. This creates a focal point—and a more interesting drawing. It's just good design!

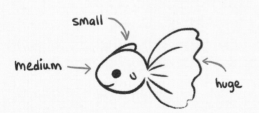

small
medium
huge

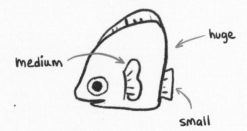

huge
medium
small

let's draw a bird!

Now on to creatures with legs, but just two legs, like birds! Birds are a bit easier than our four-legged friends, but they're no less cute.

FIND THE KEY FEATURES

Like fish, birds come in all sorts of sizes, shapes, and colors. But most birds have wings, feathers, beaks, tails, and thin legs with triangle-shaped feet.

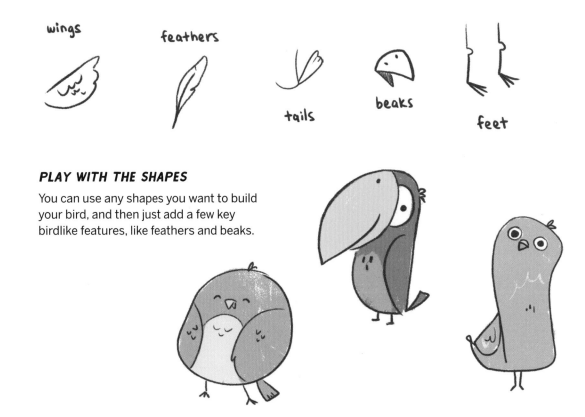

PLAY WITH THE SHAPES

You can use any shapes you want to build your bird, and then just add a few key birdlike features, like feathers and beaks.

ZERO IN ON SPECIFIC FEATURES

To draw a specific species of bird, you need to highlight elements that are unique to that species. For example, a duck has webbed feet, a long neck, and a stubby tail. With these specific features in hand, you can draw a duck that's quack-tacular!

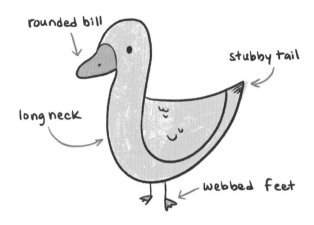

rounded bill

stubby tail

long neck

webbed feet

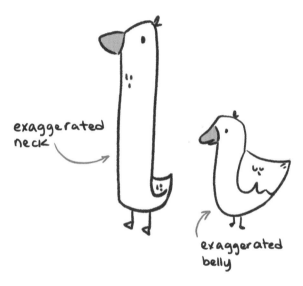

exaggerated neck

exaggerated belly

EXAGGERATE THE FEATURES FOR MEGA CUTENESS

We know a duck has a long neck. By exaggerating that feature we can make a pretty silly duck! What other features can you exaggerate?

TO ADD CREATIVITY, TRY SWAPPING OUT SOME FEATURES

Remember, if you have enough visual cues to tell your story, you can replace some key features with less classic ones, and your bird will still feel birdlike.

feathers swapped for texture

let's draw a cat

Four-legged creatures are the trickiest of the bunch. Let's try a cat—they are made up of lots of easy-to-recognize features.

FIND THE KEY FEATURES

Cats share the same basic traits: pointy ears and noses, whiskers, and long tails.

pointy ears

whiskers

tail

triangle nose

START SIMPLE THEN ADD COMPLEXITY

When drawing more complex objects, start with a rough shape and slowly add layers of detail on top. Once you have your rough drawing, you can erase some of the stray lines and draw a clean and polished drawing on top.

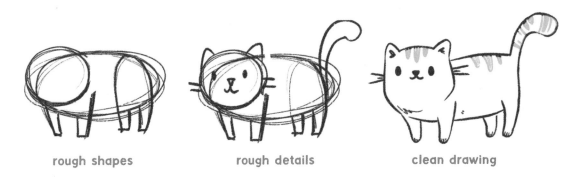

rough shapes rough details clean drawing

make it cuter!

Here are some creative ways to simplify your cat drawings and make illustrating four-legged critters a little less challenging.

MAKE IT HUMANLIKE

Maybe your cat stands up on two legs! Many artists find two-legged characters easier to draw (probably because we're more familiar with walking on two legs).

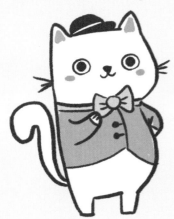

TAKE A SEAT

It's a little easier to draw an animal sitting than standing.

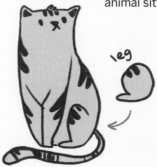

leg

SIMPLIFY THE LEGS

If you have enough key features, you can do anything you want with those li'l kitty legs!

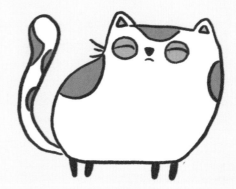

PRACTICE TIME ⤵

LET'S DRAW SOME SNAKES

LET'S DRAW SOME FISH

LET'S DRAW SOME BIRDS

LET'S DRAW SOME CATS

PRACTICE TIME

NOW CHOOSE YOUR OWN ANIMALS TO DRAW

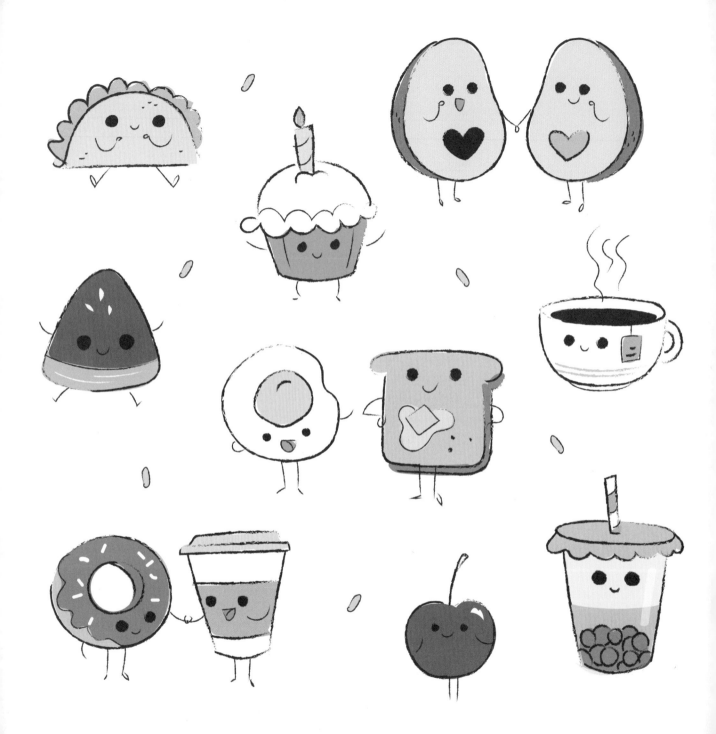

- HOW TO MAKE -

CUTE ANYTHINGS

YOU DON'T HAVE TO DRAW PEOPLE OR ANIMALS to be able to draw supercute characters. In this chapter, you'll learn how to take just about any object or shape and turn it into a character by adding a little bit of storytelling. Not only is this a lot of fun to do, but it also gives you the opportunity to make silly puns too! Best of all it's a great way to start getting comfortable with basic character design and illustration before moving on to more complex characters like people and animals.

make a character out of anything!

Art doesn't have to show humans or animals to look adorbs. You can use shapes or objects and just make them humanlike (and supercute) by adding emotion and storytelling.

PICK ANY OBJECT OR SHAPE

I suggest you start with a simple object—or even just a simple shape like a circle or a square. Keep your drawings simple, focus on the overall shapes, and remove extra details.

ADD EMOTION

Add a face, then choose simple stick arms and legs—or anything else you'd like—to give your object human emotions. Remember to put the facial features toward the top or bottom of your character's face to amp up the cute factor!

ADD DETAILS OR PROPS

You can add details, props, or other accessories to make your drawing more fun! Adding just one prop or physical feature tells us more about your character and makes them feel like a real person . . . er, walking, talking book.

GIVE THEM AN ACTIVITY

Add even more storytelling by giving your character a special pose. You can keep it simple (like drawing your character waving to the audience) or go for something complex (like dancing ballet!).

≳ tip ≲

If you get stuck on a pose, try sketching things out using a stick figure first. Then add those details to your object.

 + =

STORYTELLING MAKES CHARACTERS REAL

When you look at the first drawing below, you can see how much less personality it has than the final pass on the right. Both illustrations are cute, for sure, but the final drawing has more life, personality, and storytelling. It's unique—and more interesting too! If you're still getting the hang of poses, don't worry. You can still create charming characters by adding emotions, expressions, and extra props or details.

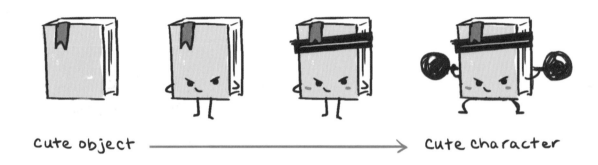

Cute object ⟶ Cute character

DIVE DEEPER BY ASKING QUESTIONS

When developing characters or stories, start by asking yourself questions about them, and then use the answers to make your characters more interesting.

When sketching out my book character, for instance, I asked: How old is it? Does it enjoy weight lifting? What's its day job? Who's its best friend? I don't have to show the answers to all of these questions in my final illustration, but by being curious, I can flesh out my character and really bring it to life.

REFERENCE FOR CUTIES

Don't get stuck—get started! Here are some objects, emotions, props, and actions for you to mix, match, and get drawing.

objects	actions	emotions	props
circle	running	sad	hats
square	jumping	angry	more hats
coffee cup	fencing	jealous	bows
tissue box	cooking	anxious	sneakers
printer	weight lifting	happy	backpack
stamp	eating cotton candy	excited	freckles
leafy plant	waving	numb	glasses
shoe box	talking to a friend	dazed	goggles
pillow	skipping rocks	surprised	tie
ruler	reading a book	shocked	mustache
sketchbook	sunbathing	sleepy	scooter
	swimming	sick	purse
		determined	sandwich
		confused	umbrella
		furious	yoga mat
		mischievous	hair
		confident	pink cheeks
		shy	eyelashes
		bored	

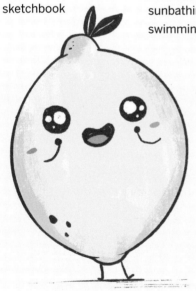

PRACTICE TIME

CREATE YOUR OWN VERSION OF THESE CUTE CHARACTERS

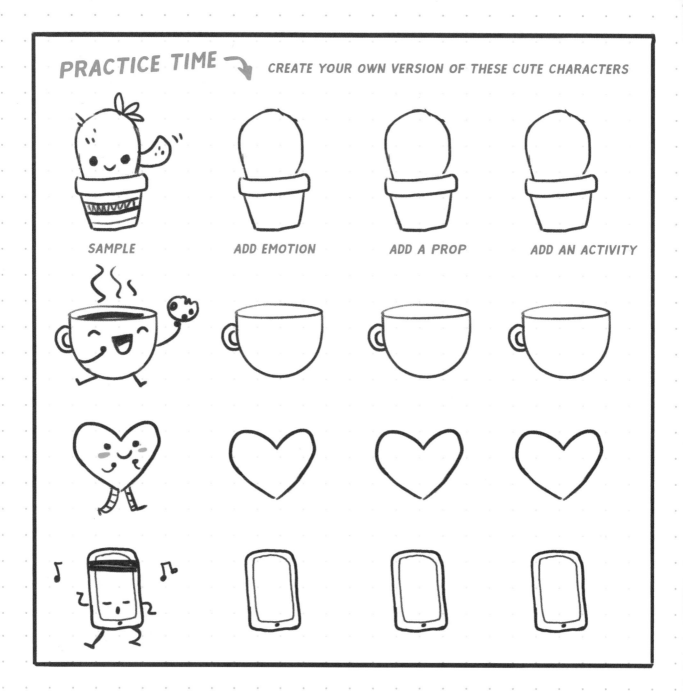

SAMPLE ADD EMOTION ADD A PROP ADD AN ACTIVITY

NOW FIND AND DRAW YOUR OWN CUTIES!

TOOT

YOU DID IT!

You've made it to the end of my book! Great job drawing your way through my guide to everything cute. I hope you were able to take advantage of the worksheet pages and create lots (and lots) of cute art! If you'd like more practice pages, please visit my website, www.carliannecreates.com. Nothing would make me happier than to see your progress as an artist, so please tag me anytime on Instagram or Twitter. You can tag my account @carliannecreates or use the hashtag #HTDA (for How to Draw Adorable).

Wondering what to do next? Well, the answer is simple. Go make more cute art! The more you draw, the better you'll get, but remember to always . . .

Have fun and make cute stuff!

about the author

Carlianne Tipsey is an award-winning children's book illustrator and mentor.

She began her career working in games for Disney Interactive, where she got to draw princesses all day. She later worked as a senior illustrator for KiwiCo, a kids' creativity company.

For the last ten years she has helped mentor her colleagues in illustration and has taught children complex STEM concepts with cute and simple illustrations.

Carlianne is perhaps most well known on Instagram and YouTube, where she teaches simple cute art tips to help anyone learn how to draw.

In her free time (what's that?), she enjoys wrangling her two beautiful children and reading them books she has illustrated. When the lights go out, she's back to work creating tutorials to inspire other artists to create their own cute stuff. Because the only thing better than cute art is *lots* of cute art.